Made in the USA Coppell, TX 07 December 2019

12496370B00072